So often, I hear people say, "I'm not good with color". That never has to be the case. Understanding color is simply a matter of learning certain information and practicing making color choices.

I have been teaching the color theory principles in this coloring book for more than thirty years. My art students tell me that this information transforms their ability to see and reproduce color. It is also tremendously helpful for making every-day color decisions, such as what clothes look good together or coming up with home decorating ideas.

By the time you finish the exercises in this coloring book, you will have a solid understanding of color theory and behavior. Relax, it's just coloring!

Have fun playing and learning all about color!

Carol Bowen

Materials

- Black
- White
- Yellow
- Orange
- Red
- Purple
- Blue
- Green

Use crayons (not pastels) for the color exercises. The optical effects work best if you color neatly and thoroughly. Don't leave any white spots because white areas affect the color contrasts. Have fun learning about color!

How to Mix Colors with Crayons

1. If you are mixing colors, make marks lightly, leaving some white spaces between marks.

2. Adding a new color to the mixture, render your next layer lightly, leaving some spaces between marks.

3. Continue to build light layers until you have made the mixture you want.

How to Color a Solid Hue

For the purposes of this coloring book, when you are coloring a shape a single hue (no mixing), press firmly with the crayon and try to fill in all the white spaces.

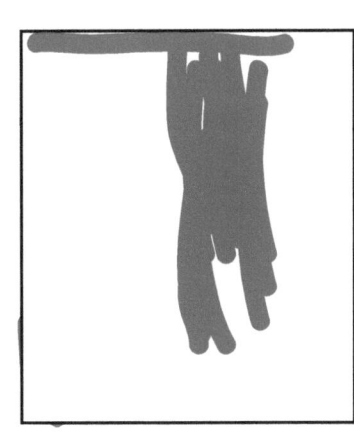

How to Color Edges

When you color up to the edges like this, it's hard to control where the mark stops. That makes it hard to get an even edge.

I usually color near the edges of the shape in the same direction as the shape.

ee

Practice Coloring Edges Here

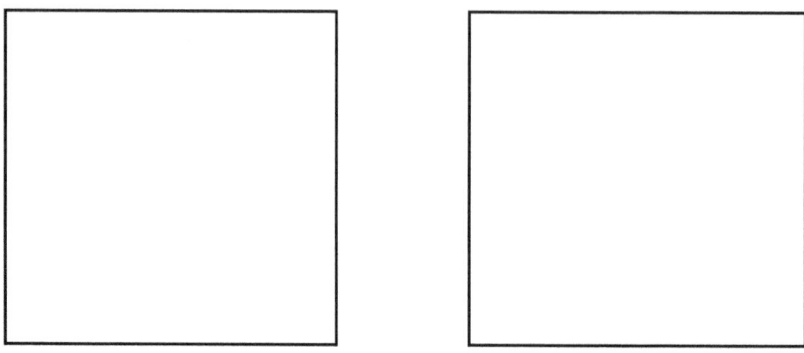

A few more pointers...

Its hard to control long strokes. They tend to curl with the movement of your hand.

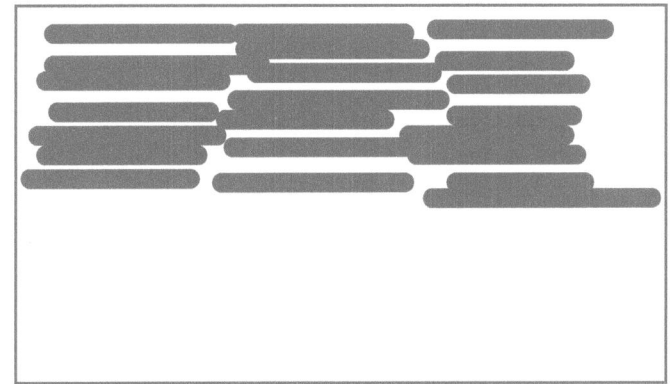

It's easier to make straight lines when you make short strokes.

ee

Line Direction

Free-form

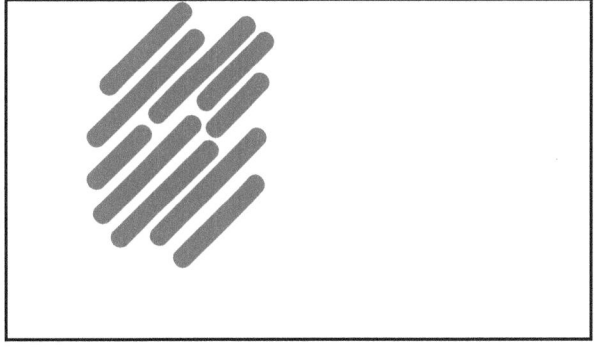

Lines going in one direction

Cross-hatch up, down and sideways

Cross-hatch up, down, sideways and diagonally

Practice Different Ways of Coloring

Short Strokes

Try Dotting........

Free Form

Lines all in one direction

Cross-hatch up, down and sideways

Cross-hatch up, down, sideways and diagonally

The inspiration for this book comes from a French chemistry professor who lived in the 1800's named Michel Eugene Chevreul. Chevreul designed a complex color wheel and developed a system for mixing colors. His book, "The Law of Simultaneous Color Contrast," had a great impact on the history and practice of painting. It inspired Impressionist painters like Monet and Renoir, who applied Chevreul's concepts to their art. Interestingly, Chevreul was also the inventor of margarine.

Chevreul became interested in color when he worked for a dye manufacturer in Paris. Customers complained because the black fabric looked different when it was placed next to various colors. Chevreul decided to study this puzzle.

Does black look different next to different colors?

Let's find out! Color the small square in the center of each of the large squares black. Don't leave any white spaces. Color a different hue in the wide border around each black square. Does the black square appear different when it is surrounded by different colors?
If so, how?

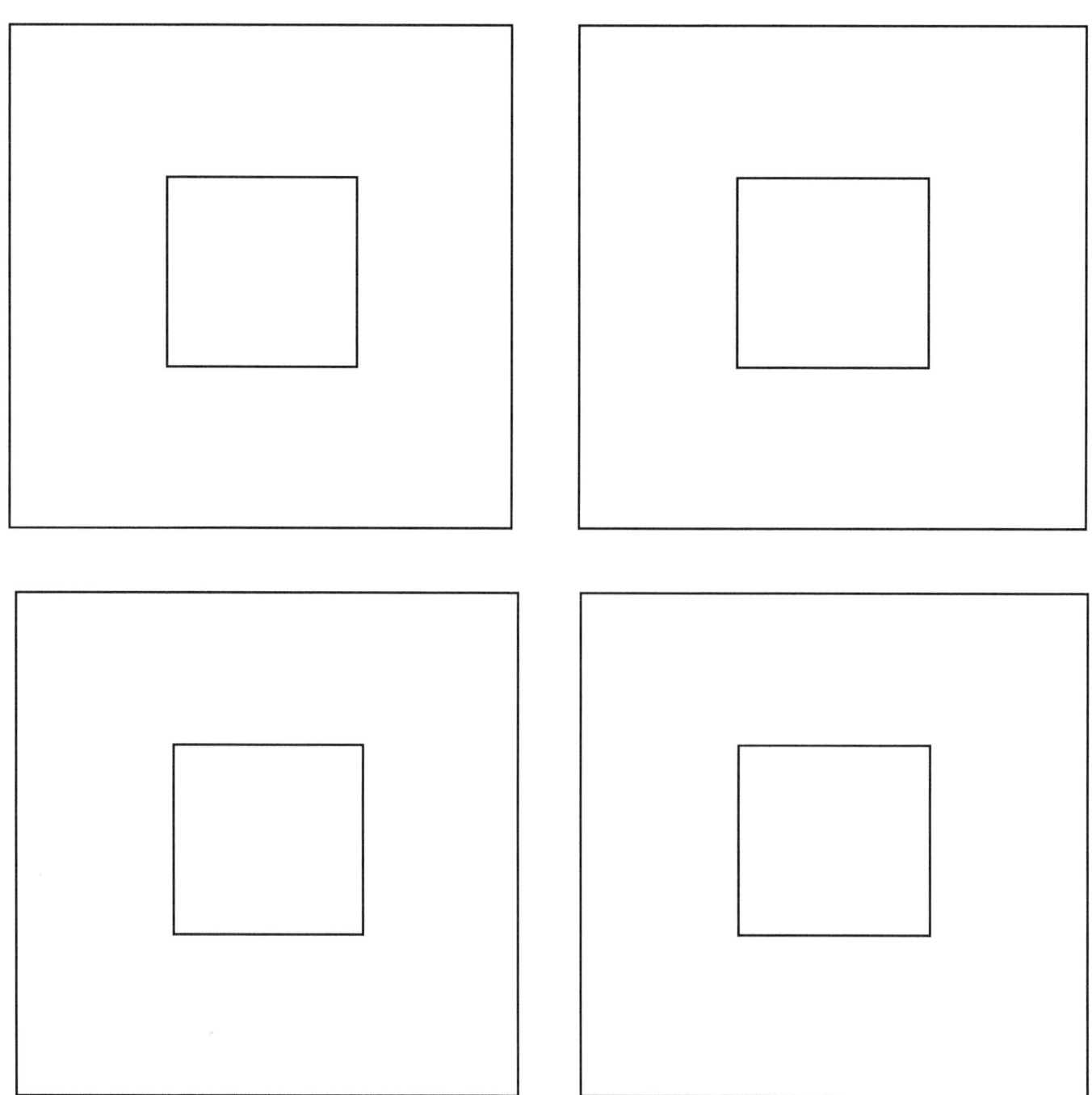

Chevreul decided that an optical illusion made the black dye color look different when surrounded by different colors. An optical illusion is a trick of the eye, not reality. Chevreul's study of these tricks, or optical illusions, led him to write his famous book, "The Law of Simultaneous Contrast in Color", which was published in 1839.

The Halo Effect

The "Halo Effect" was one of the optical illusions Chevreul discovered. Try this experiment to experience the Halo Effect. Color the large rectangle below yellow. Leave the small boxes white and black.

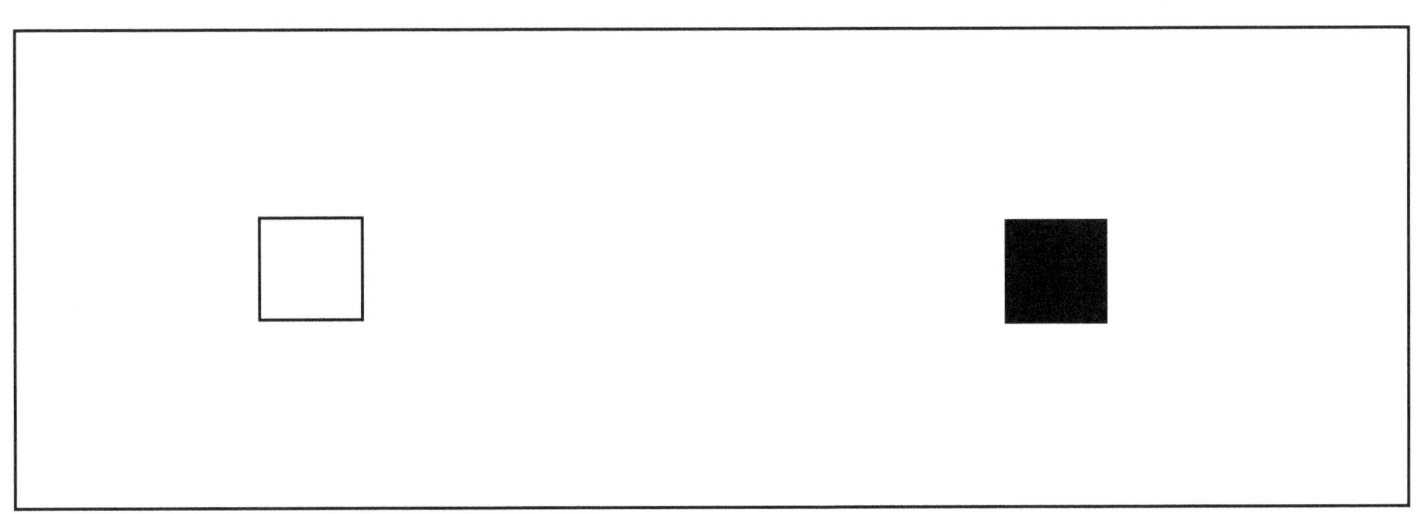

Notice that the yellow crayon surrounding the white box appears dark, like a dark halo. The yellow crayon surrounding the black box appears light, like a light halo. You know that the yellow color is the same behind both the white and black squares—after all, you colored it! But the effect of the strong contrast against each square creates the halo effect.

Space and Value

"Value" means tone, or darkness and lightness. When a color is against different values, not only does the contrast make different halos, the color seems to advance or recede in space.

Color the wide border around the gradation green.

Notice how the green border appears dark near the white end of the bar and light near the black end of the bar. Also notice how the green appears to recede at the light end, yet it seems to pop forward near the dark end.

1. Black

2. Dark Blue

Value

"Value" means tone,
or darkness and lightness.

A value scale is a chart that
shows the different darkness
and lightness, or
tints and shades of a color.

Color two value scales
1. Black to White
2. Dark Blue to Light Blue

Try to keep the change in value
even from square to square.

White

Light Blue

Temperature and Color

One of the qualities of color is it's "temperature". Colors are described as either "warm" or "cool".

Warm Colors
Warm colors are colors that we associate with heat. Warm colors include Yellow, Orange and Red.

Cool Colors
Cool colors are colors that we associate with ice, winter or cold water. Cool colors include Blue, Green and Purple.

Notice that warm colors occupy one half of the color wheel and cool colors occupy the other half.

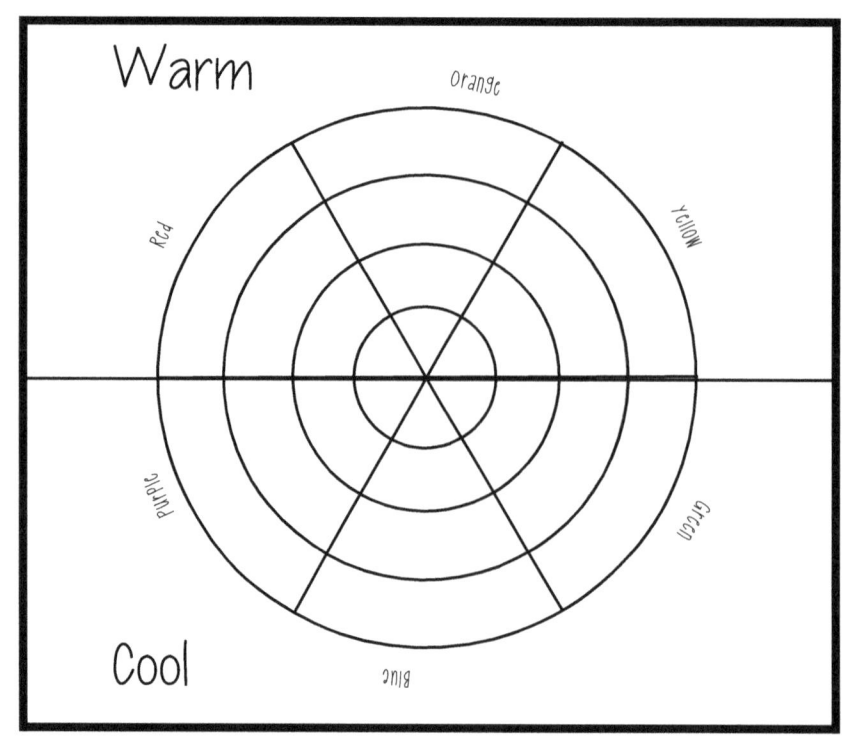

Color in Space

We always see color surrounded by other colors. The relationship between nearby colors creates optical illusions.

Try this experiment.

1. Color the small squares inside both large squares red.

2. Color a warm hue in the large square surrounding the small square.

3. Color a cool hue in the large square surrounding the small square.

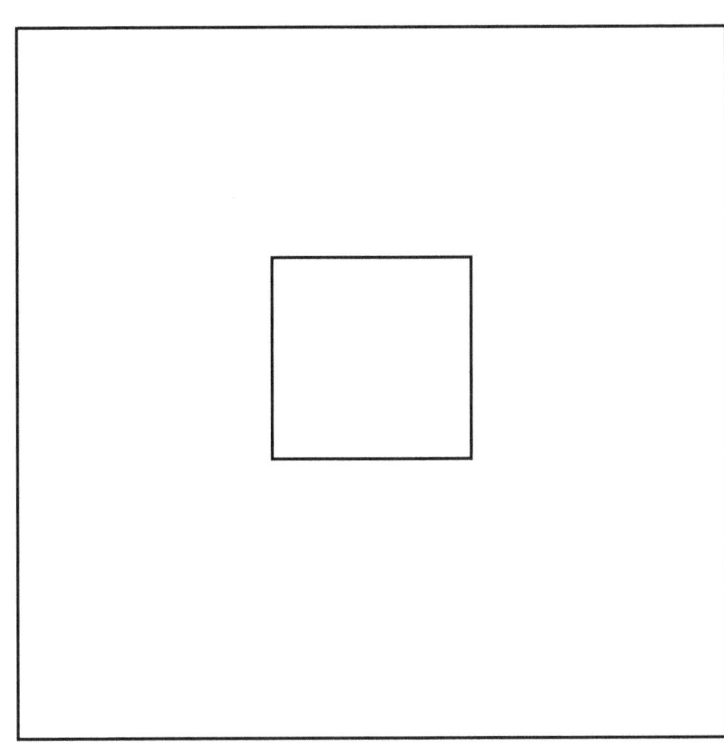

More often than not, cool colors appear to recede (move backwards) in space and warm colors appear to advance (move forward) in space.

Was this true for you?

Do you think that the lightness or darkness of the color effects whether it advances or recedes?

As a result of his research Chevreul created a complex color wheel and developed a system for mixing colors.

Chevreul's color wheel has 72 hue increments around the outer circle! Don't worry--the one you will be coloring in this coloring book only has six!

On the next page is a simplified version of Chevreul's color wheel. The term "hue" means color. Follow these directions to color your color wheel.

Directions:
- In the outer ring: render the pure hue
- In the 2nd ring: Hue mixed with white (tints)
- In the 3rd ring: Hue mixed with black (shades)
- In the inner ring: Hue mixed with its complement (complement means opposite color on the wheel)

Color Wheel

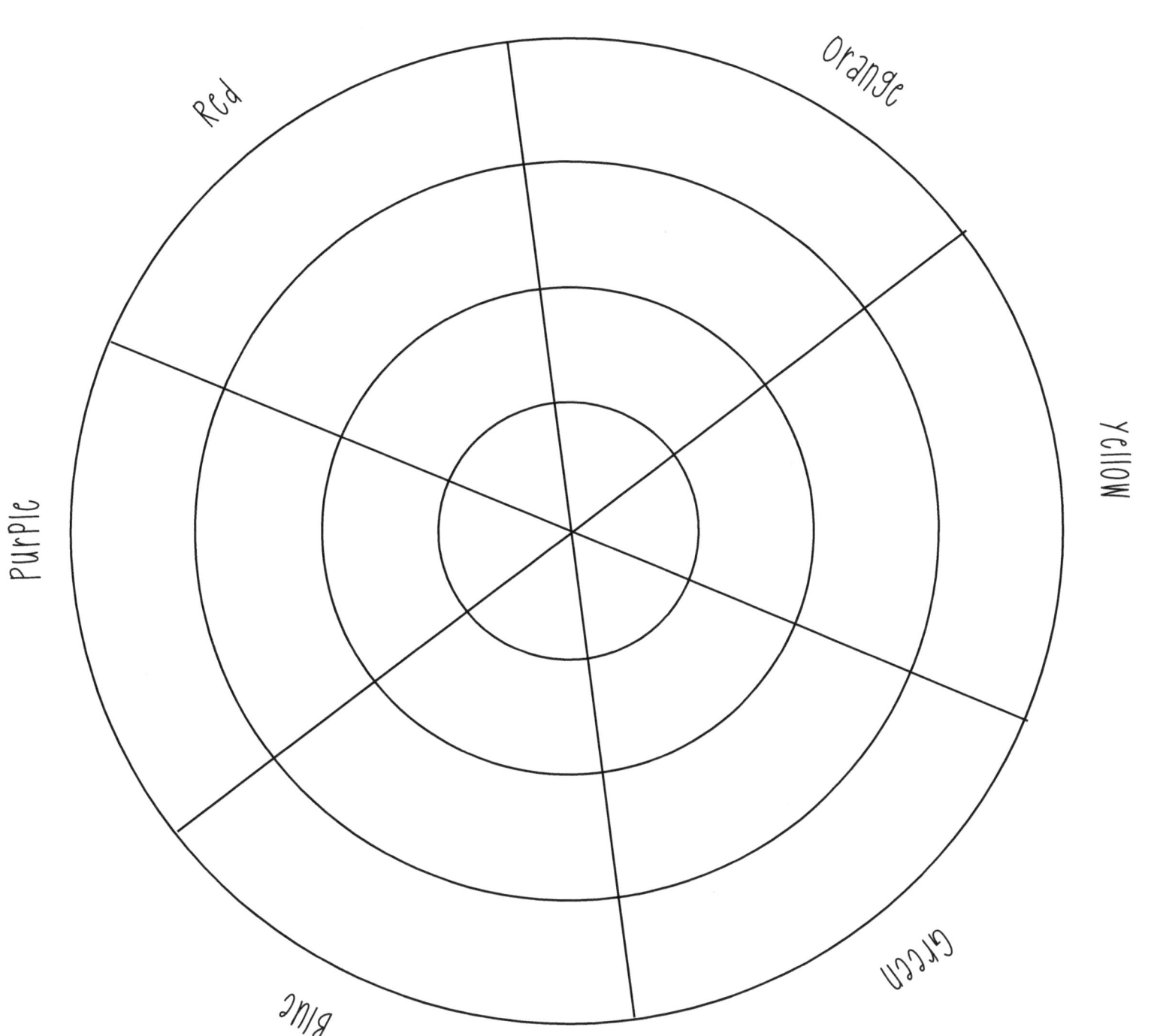

Opposite Colors

Chevreul discovered that when you put two colors that are opposite each other on the color wheel next to each other, they are at their most intense. Opposite colors are called complementary colors, or complements Below, color the three basic sets of complementary colors.

Purple and Yellow

Green and Red

Blue and Orange

Broken color

As soon as you mix even the tiniest amount of another color into a color you have "broken" the color. This term is used because when a color is a pure hue (unmixed, straight out of the box crayon color or if you are talking about paint, the paint right out of the bottle), that color is at its most intense.

When you mix in another color, you have broken the color once. When you mix in yet another color, you have broken it twice. When you mix in yet another color...you get the idea..

With each break, the color becomes duller.

Try this experiment:

Color this circle with a pure green crayon

Color this circle by mixing together yellow crayon with blue crayon. (Making a broken color)

Do you notice a difference in intensity between the pure green and the mixed green?

What happens if you put broken versions of opposite colors next to each other?

Break each color by mixing a small amount of its complementary color in it.

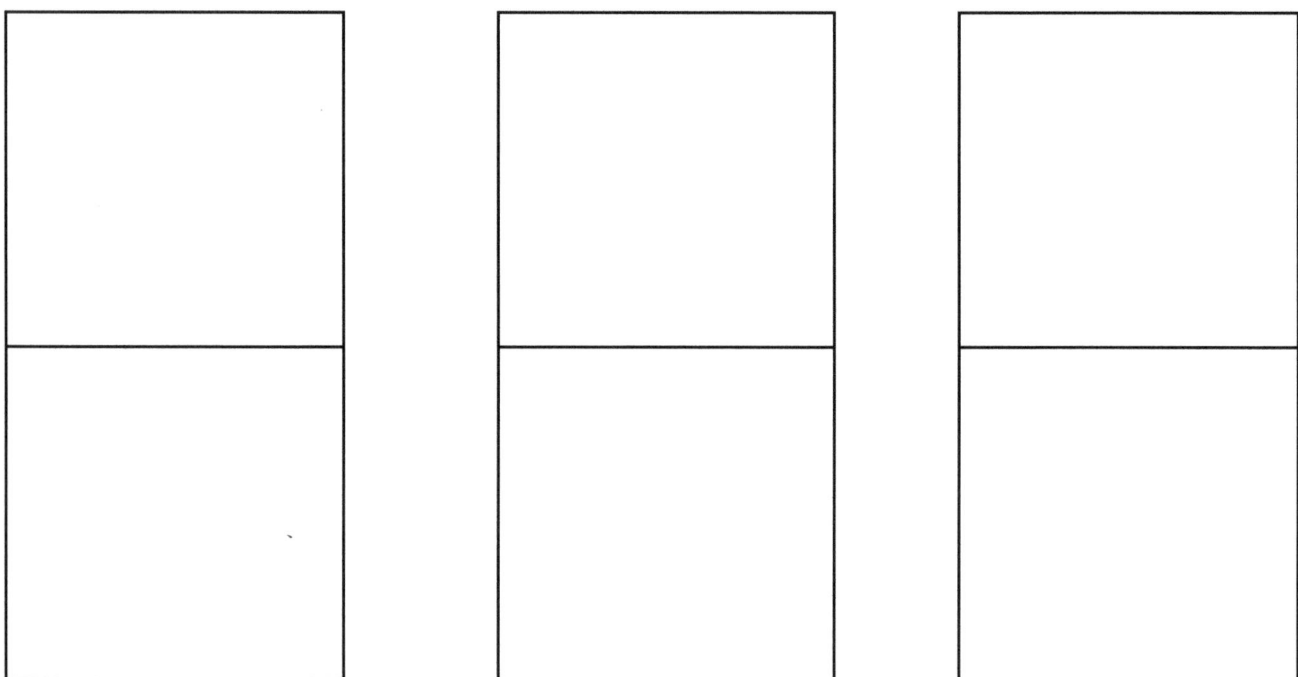

Purple and Yellow Green and Red Orange and Blue

Even when you break a color, the rules of coomplementary color apply. A dull blue will intensify a dull orange.

What happens if you put tints of opposite colors next to each other?

Color tints of each pair of complements. For example, place a pale blue in the square next to a pale orange.

The Effects of Breaking Colors

Each time you break a color (add another color to it) you dull the color. When someone refers to a color as "muddy", the color has been mixed with other colors so many times that it looks dense and ugly.

How many times can you break a color before it looks like mud? How muddy can you make it?

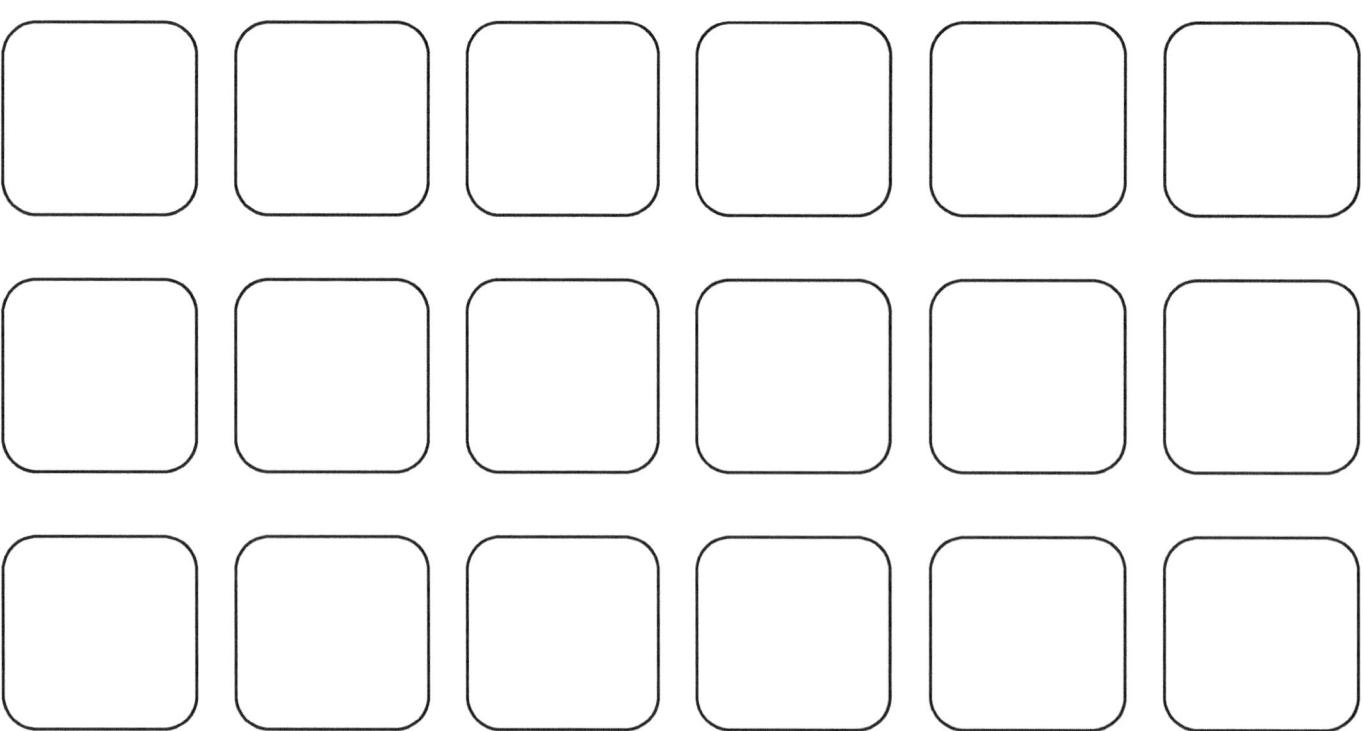

What happens if you put shades of opposite colors next to each other?

Paint shades of each pair of complements. For example place a dark blue in the square next to a dark orange.

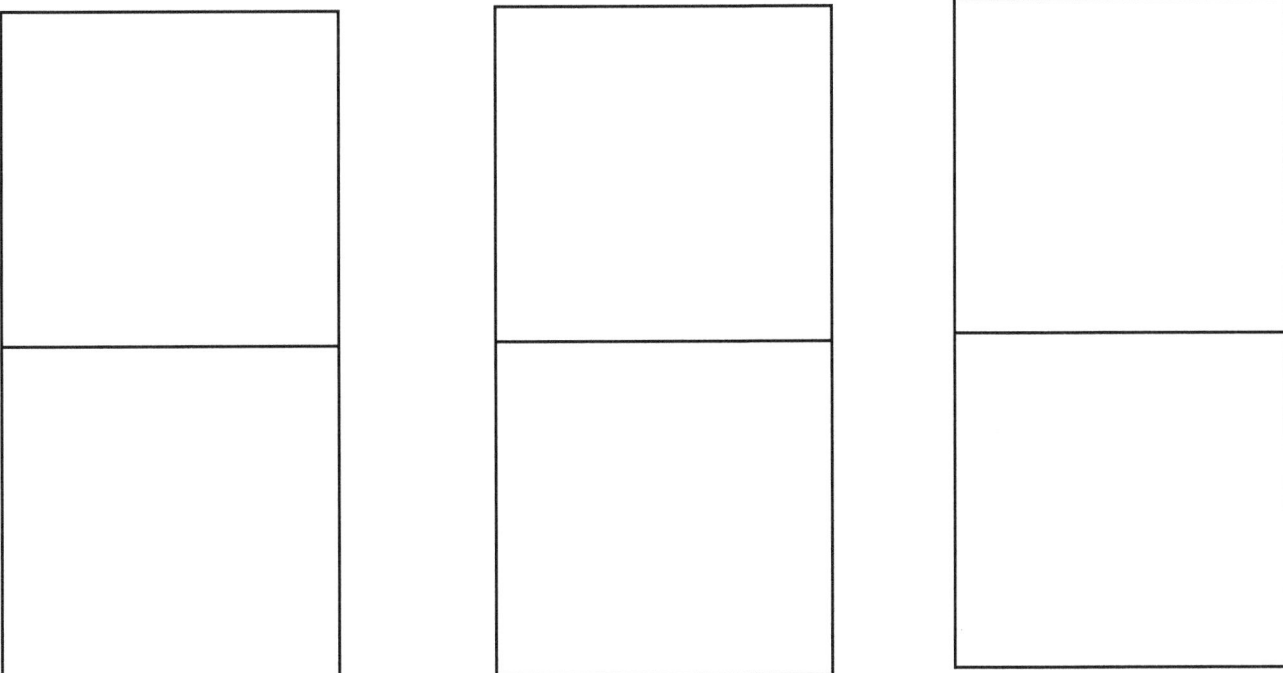

Even when they are lightened or darkened (tints or shades) complements always enhance each other. Any kind of blue will enhance any kind of orange.

Intensity

The intensity of a color is how vibrant the color appears. Some colors are naturally more intense than other colors. Create a scale showing which of your crayons is more intense than the others.

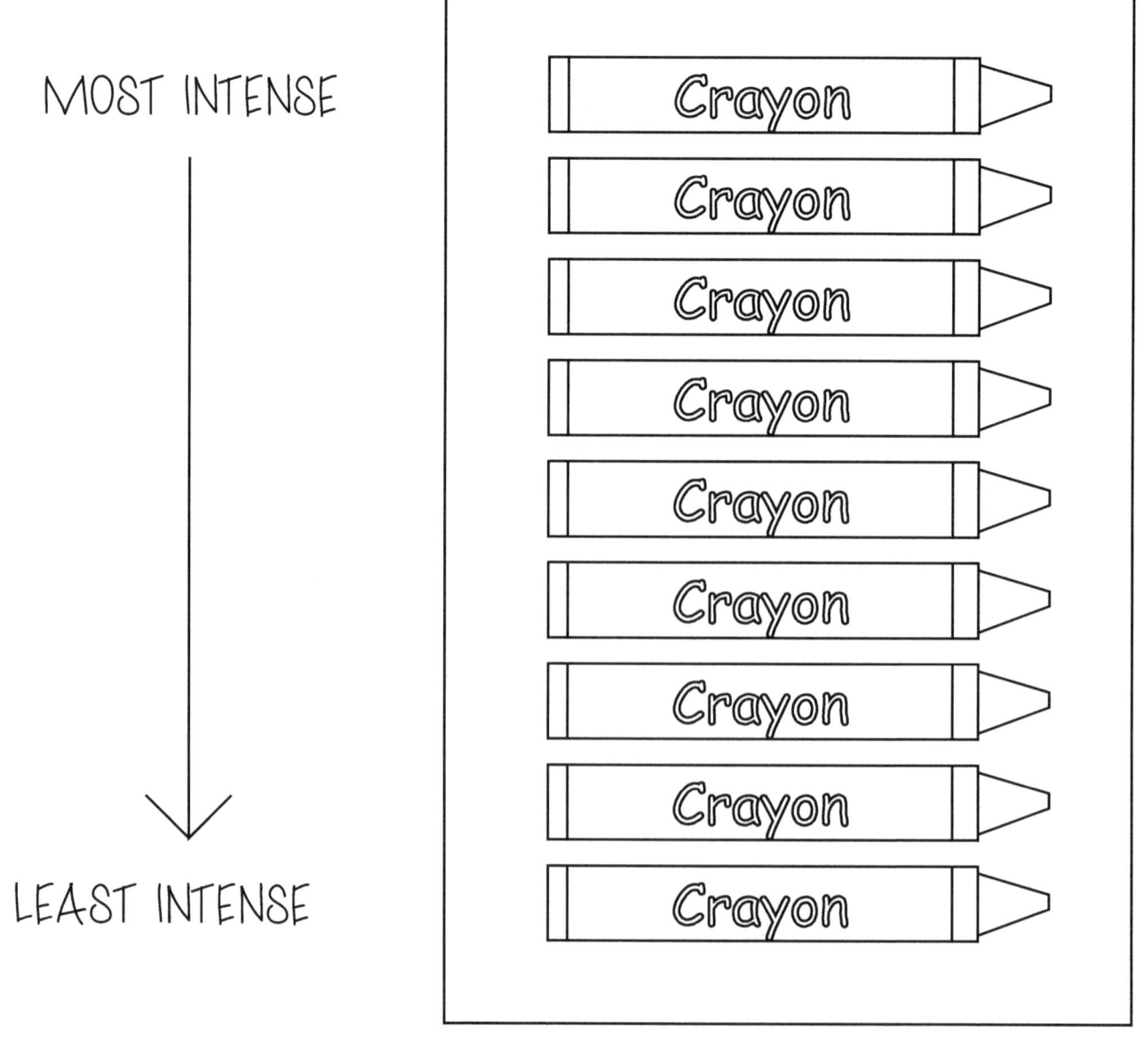

MOST INTENSE

↓

LEAST INTENSE

Color Terminology

These are some terms that describe color. If you want to reproduce a color that you see in the world with paint or crayons, these are the factors you examine to match the color.

Hue: The color (in this case the "yellowness") of the color

Tint: A hue PLUS White

Shade: A hue PLUS Black

Luminosity: How much light is reflected from the color (its tone)

Intensity: How vibrant is the color?

Explore your favorite color!

Render your favorite color in the circle

Render a tint of the color

Render a shade of the color

Render the color in two different levels of luminosity

Render the color in different levels of intensity.

Transparency

"Transparent" means "see-through"

There is a trick you can use to make color look transparent.

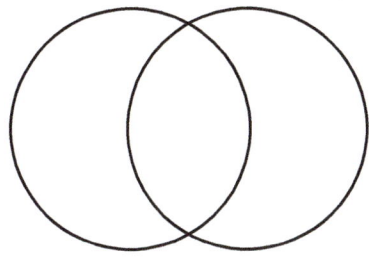

1. Color one side of the design blue.

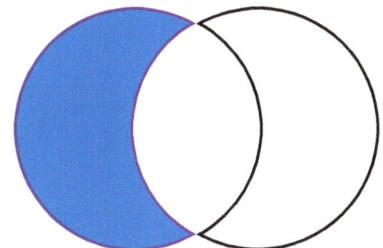

2. Color the other side of the design orange.

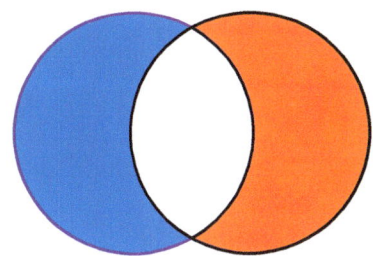

3. Mix a combination of blue and orange in the middle space

4. It looks like you have two overlapping shapes, even though you really have three shapes.

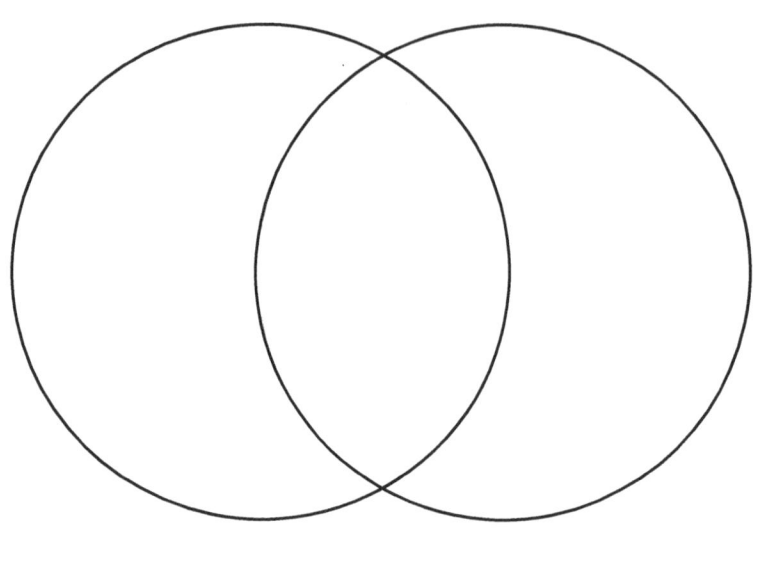

Choose any two colors. Try to create the illusion of transparency within the circles on this page.

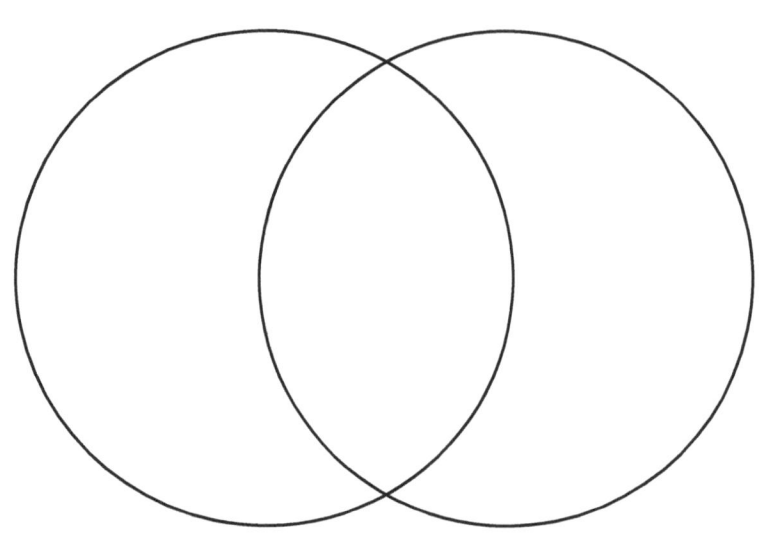

What happens if you put more of one color than the other in the middle shape?

Create the illusion of transparency in the design.

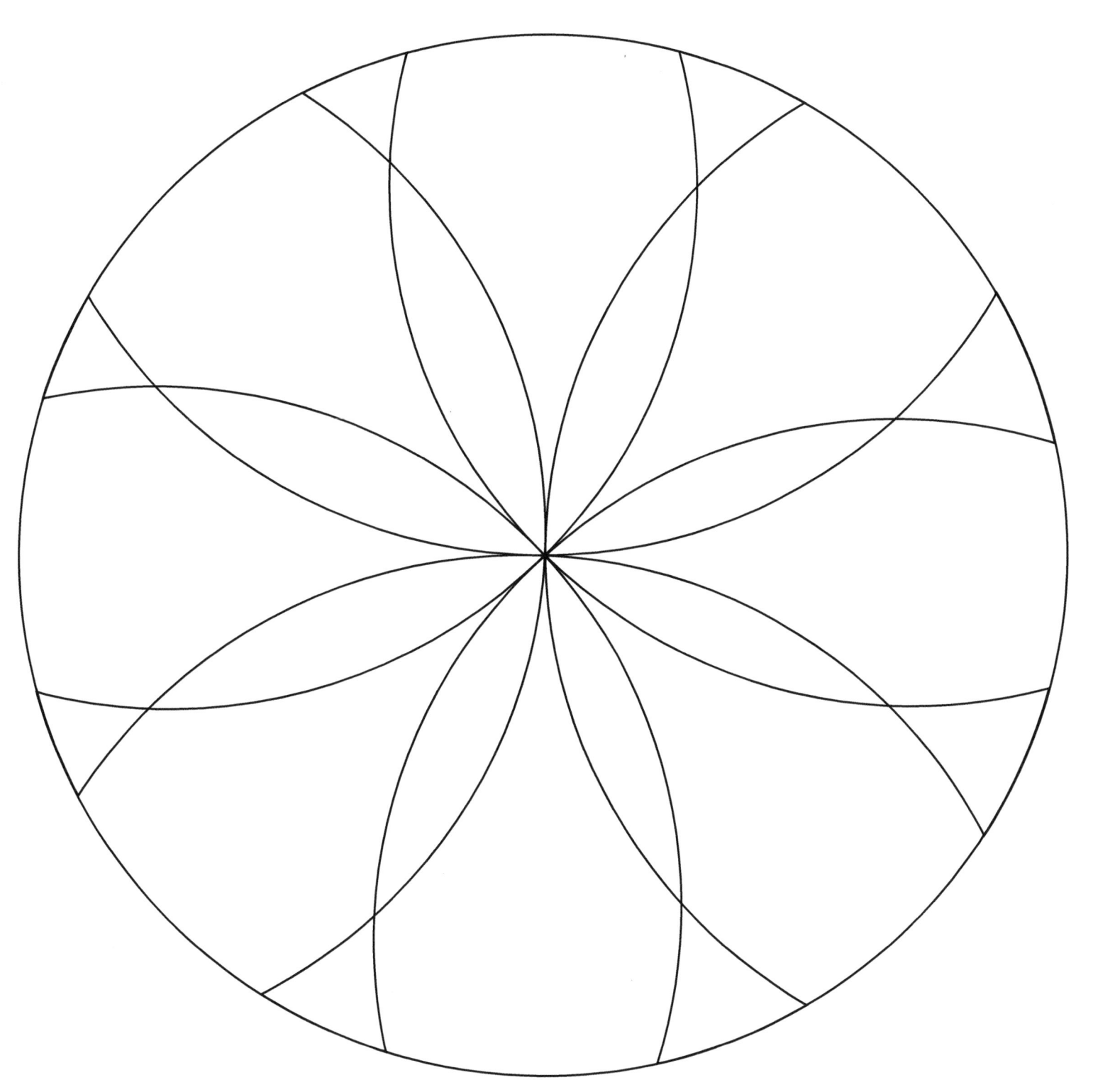

There's more! Color Schemes

Color schemes are arrangements of colors that are dependable. Using a color scheme is a way of guaranteeing that the colors in your artwork (or your clothing, or your interior decoration) look good together.

Monochromatic Color Scheme

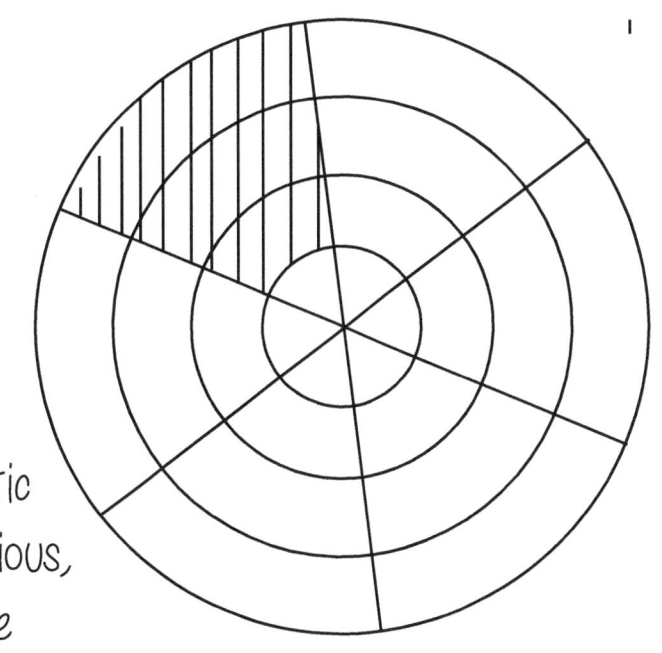

Monochromatic colors are tints and shades of a single color. Using monochromatic colors makes an artwork harmonious, but it can be boring because there is no variety.

Analagous Color Scheme

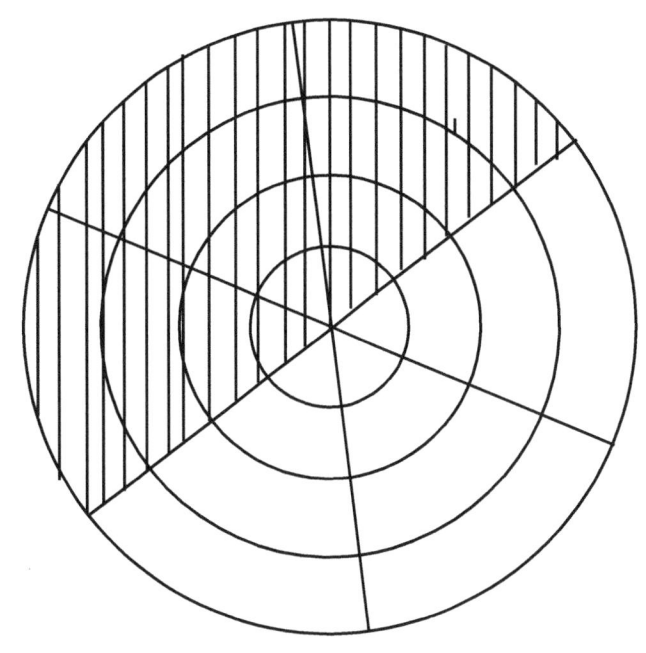

Analagous colors are colors that are next to each other on the color wheel. Using analgous colors gives an artwork a sense of harmony.

Complementary Color Scheme

A complementary color scheme uses two colors that are opposite each other on the color wheel.

Tetrad Color Scheme

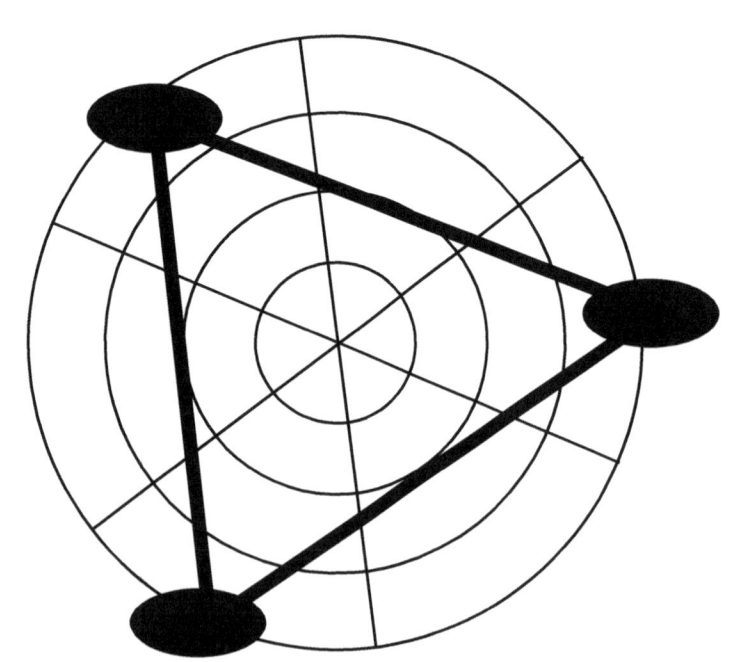

A tetrad color scheme uses three colors, evenly spaced around the color wheel.

Double Complementary Color Scheme

A double-complementary color scheme uses two pairs of complements.

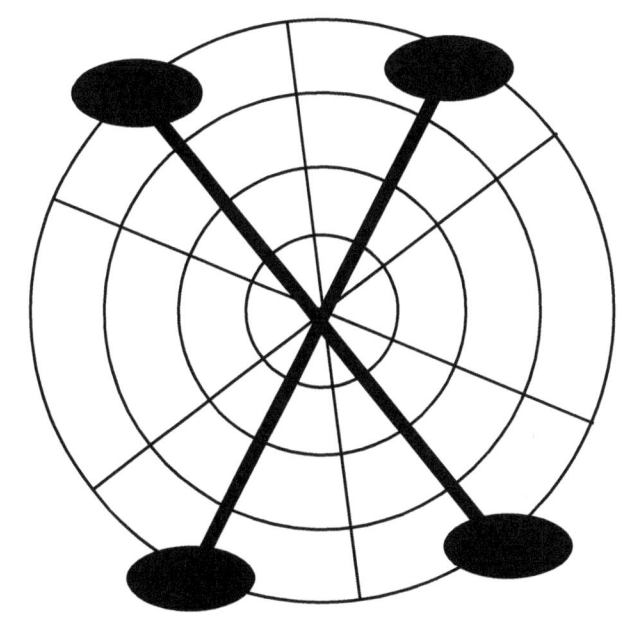

Tertiary Colors

A tertiary color is a mixture of a primary color plus the secondary color next to it. For example, Red-Purple is the tertiary made from mixing the primary color Red with the secondary color Purple.

Split Complementary Color Schemes

A split complementary scheme uses a primary or secondary color, plus the two tertiary colors next to its complement.

Edward Armfield, The Best of Friends, Bichon and Terrier, 1800's

Impressionist paintings look traditional to us today, but in it's time, Impressionism was considered radical and was given terrible reviews by critics.

Most art of the 1800's was "Academic Art". Academic paintings were done by covering the canvas with a brown coat of paint, and painting translucent colors on top of this underpainting. This approach gives Academic Art its characteristic brown look.

Impressionist painters read Chevreul's book and began applying his color theory ideas to their paintings. Rather than starting with a brown underpainting, the artists applied dabs of color directly to the canvas. This approach allowed them to keep the colors brighter

Camille Pissarro, Le Quai Malaquais et L'Institut, 1903, oil on canvas

However, they didn't want all the colors to be bright, only some of them. This is where Chevreul's work came in really handy. It started with the painter Camille Pissarro, known as "The Father of Impressionism". He told the other Impressionists, "Always paint as if it were a gray day."

Pissaro's paintings were made almost entirely with dull colors. He arrived at those dull colors by mixing opposite colors together, referring to Chevreul's color wheel.

In this Pissarro landscape, "Village Path", everything is painted in the "gray" area of Chevreul's color wheel. In other words, all the colors are broken colors. Pissarro didn't form the houses and trees by using strong light and shadow. Instead he used very subtle color and tonal changes.

Camille Pissarro, "Village Path", 1875, oil on canvas

Pissarro's paintings are made up almost entirely of broken colors. He placed dull oranges next to dull blues, muted yellows near muted purples. We know that even dull versions of complementary colors will enhance each other.

BUT--Pissarro jazzes it up even more. He throws in a few touches of pure color to "turn on" the other colors.
Can you find any spots of pure color in this Pissarro landscape?

In this painting by Claude Monet, some of the colors are blocked. What you can see of this snow scene is painted in muted colors.

Claude Monet, "Red Houses at Bjornegaard in the Snow, Norway", 1895, oil on canvas

This is how the painting really looks. Notice how Monet used complementary color to make the scene vibrant, even though most of the colors are fairly muted.

Here is another example of how Monet used mostly broken colors in his painting. (Parts are blocked)

Claude Monet, "Pleasure Boats at Argenteuil", 1875, oil on canvas

What happens when we uncover the areas of almost pure color?

Optical Color Mixing

Georges Seurat, The Parade, Oil on Canvas, 1889

Georges Seurat (1859-1891) was another French painter who was greatly influenced by Chevreul's's color theories. Seurat explored them through painting and invented a technique called Pointillism. Instead of mixing colors on the palette, Seurat painted dots of hues next to each other on the canvas. From a distance, the colors blur and blend in your eye—a phonomenon called optical mixing.

On the next page is a detail from the painting "The Parade". In it you can see Seurat's pointillist technique. In the square below the detail, use dabs of crayon to copy the detail of the painting.

Next page: detail showing pointillism. Both Seurat images are in the public domain.

Play with Optical Mixing

Make Tiny Tops:

Color each circle in two colors.
Stick a sharp pencil stub through the center.
Spin it like a top.
You will see optical color mixing in action!

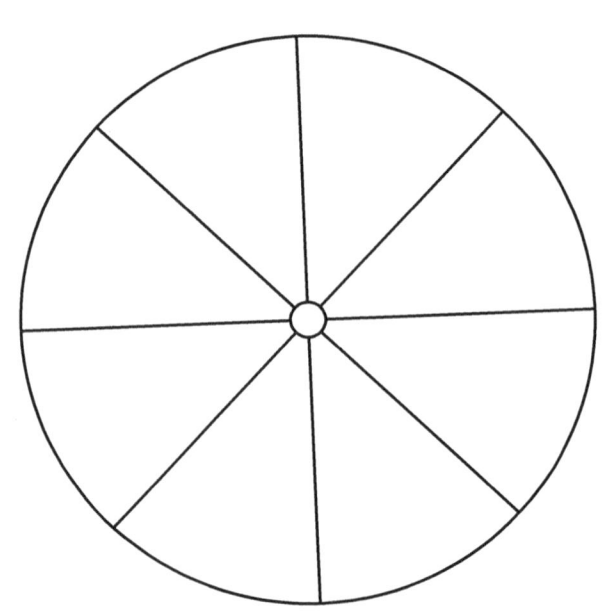

Victorian House

Victorian architecture is famous for its use of fanciful color. Draw a Victorian house, or a gingerbread house using an analagous color scheme.

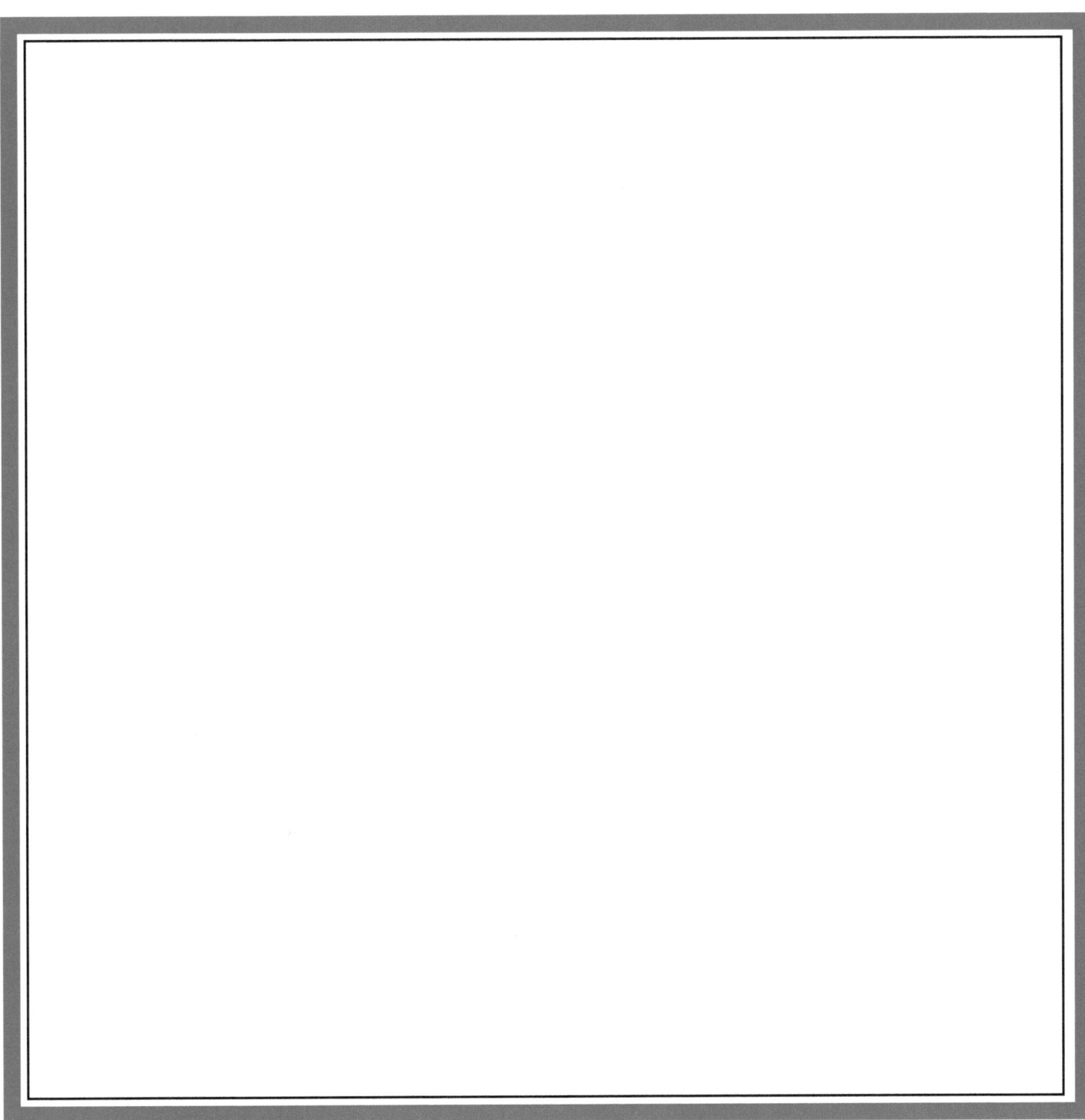

Quilt Block

This quilt block is a Log Cabin Design. Color the quilt block with a color scheme of your choice.

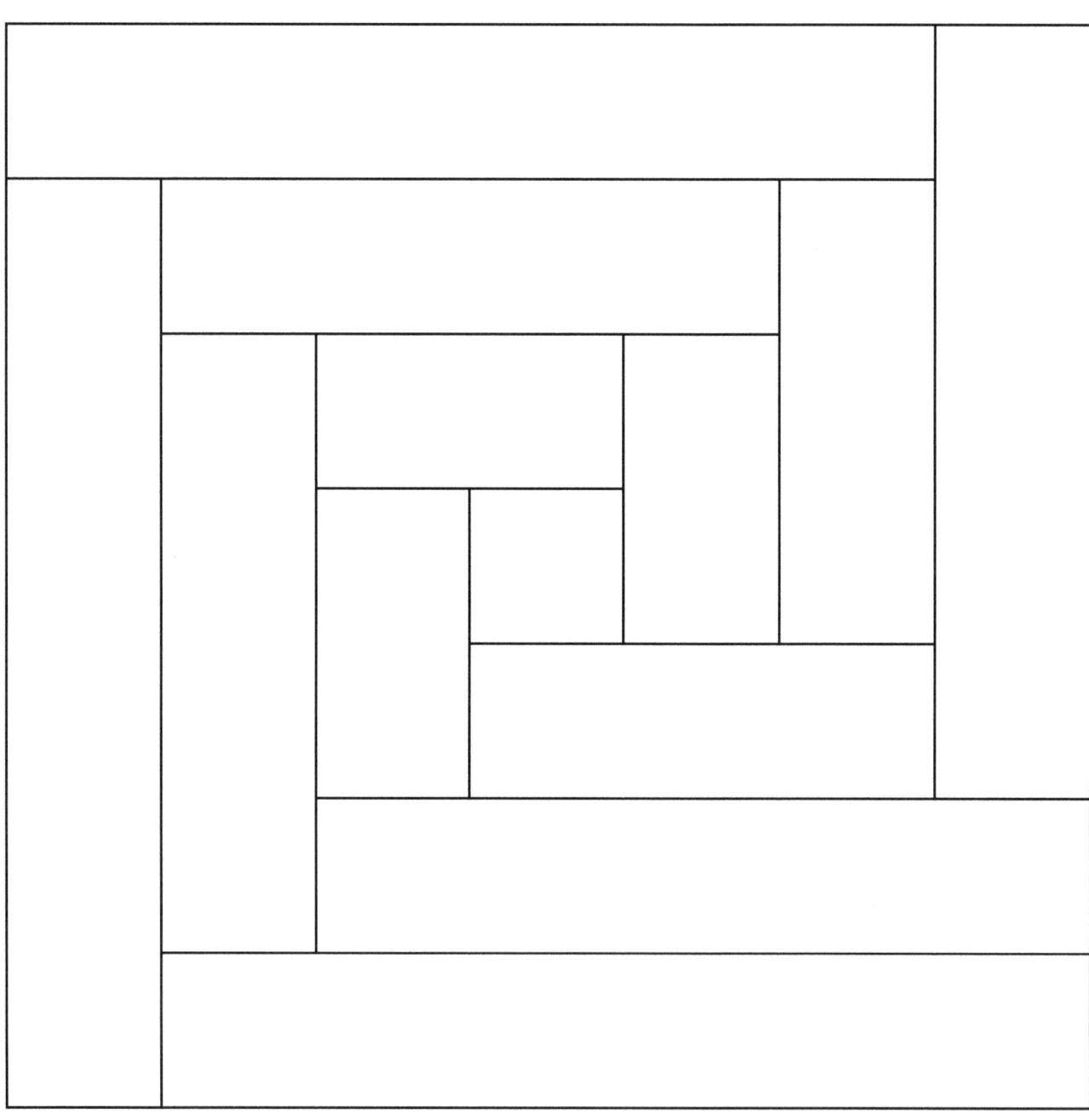

Color Scheme: _____

Under the Sea

Is there any place on this planet with more exciting colors than under tropical seas?. Draw an underwater scene using a tetrad color scheme.

Birds of a Feather

Invent a bird with fabulous plumage. Color your bird in the color scheme of your choice.

A PERSONAL LOGO

Design a logo from your initials.
Use colors that communicate the image you want to convey.
For example, if you are a Vampire, you might want to use
Black and Red. If you are a Clown, you might choose
Primary Colors.

♥ Loving Thanks to Patrick, Hansen and Dad
In Memory of Leonard DeLonga.

Carol Bowen's Blog:
http://artlessonlaunchpad.blogspot.com/

Copyright information:
This work is licensed under a Creative Commons
Attribution-NonCommercial-NoDerivs 3.0 Unported License.

www.ingramcontent.com/pod-product-compliance
Lightning Source LLC
Chambersburg PA
CBHW040745200526
45159CB00023B/1740